leslie PARKE

© Leslie Parke
Painting Photographs ©Jonathan Barber
Studio Photograph p34-35 ©Jim McLaughlin
Book design by Nina Duncan / Paparella Creative
Cover Image 'Silver Summit' by Leslie Parke

ISBN 978-1-326-07818-8

Copyright © 2021 Leslie Parke
All rights reserved

# A YEAR INSIDE
## PAINTING IN THE TIME OF COVID
### 1 MARCH 2020 - 19 MARCH 2021

paintings & text by Leslie Parke

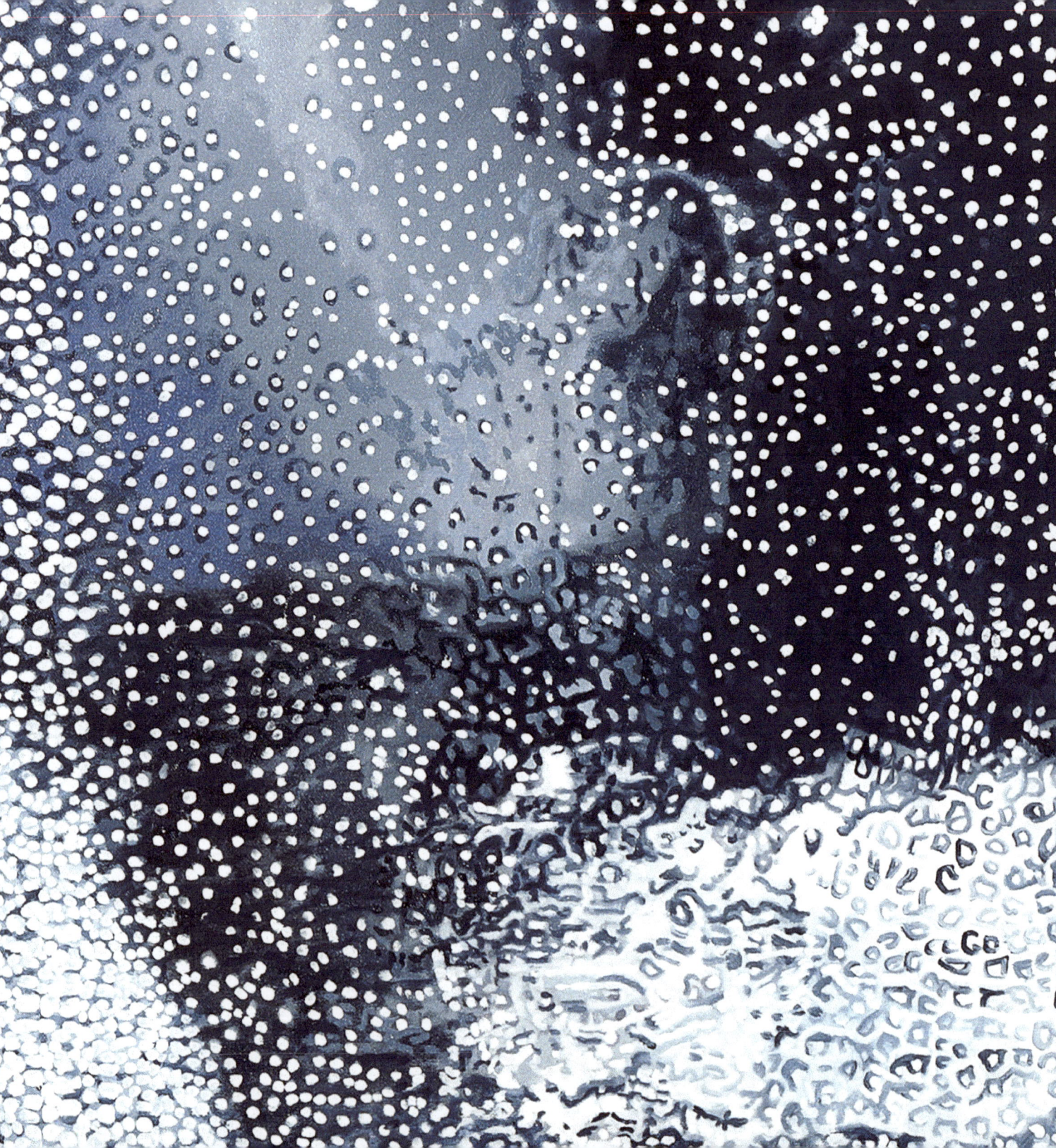

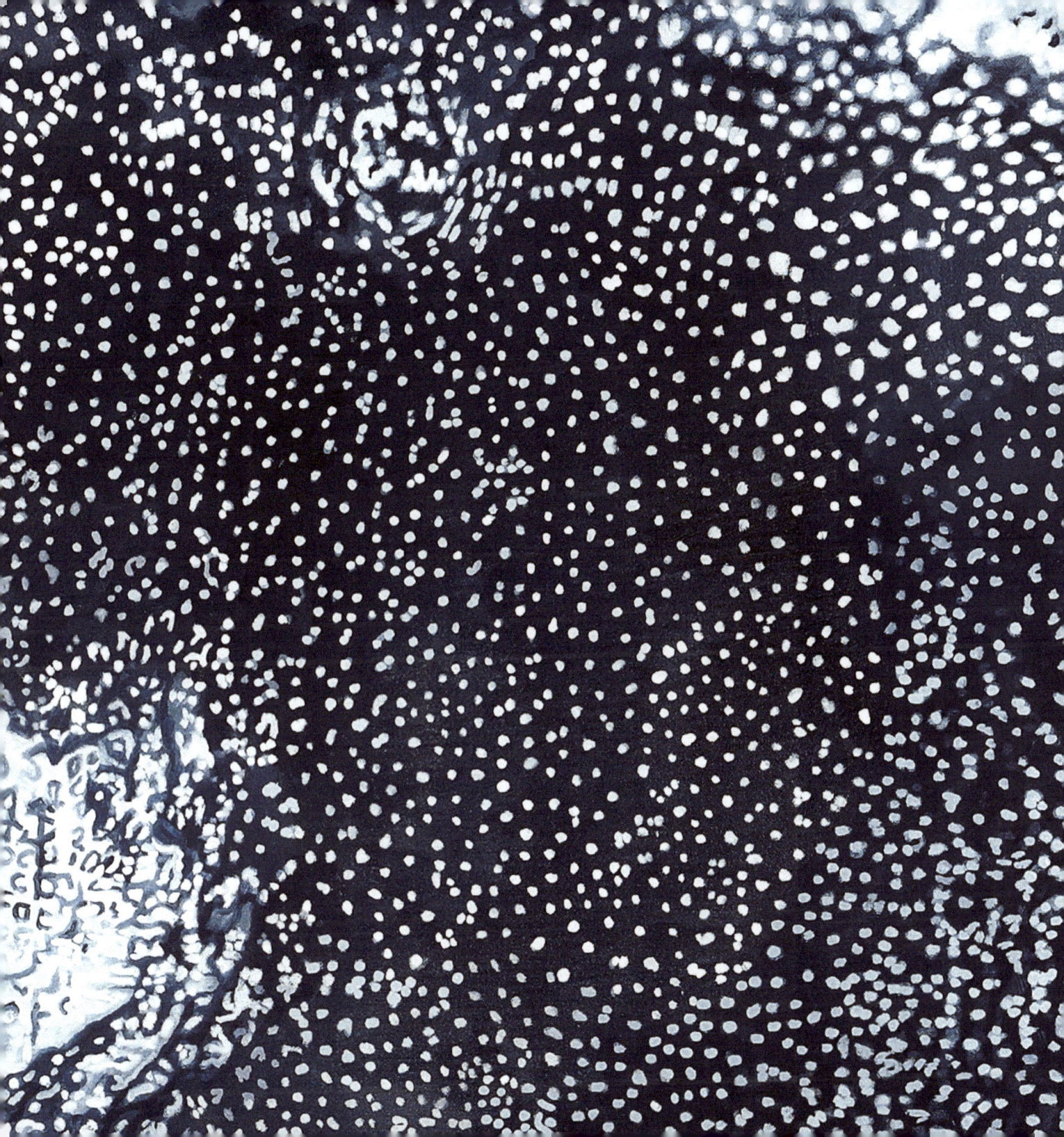

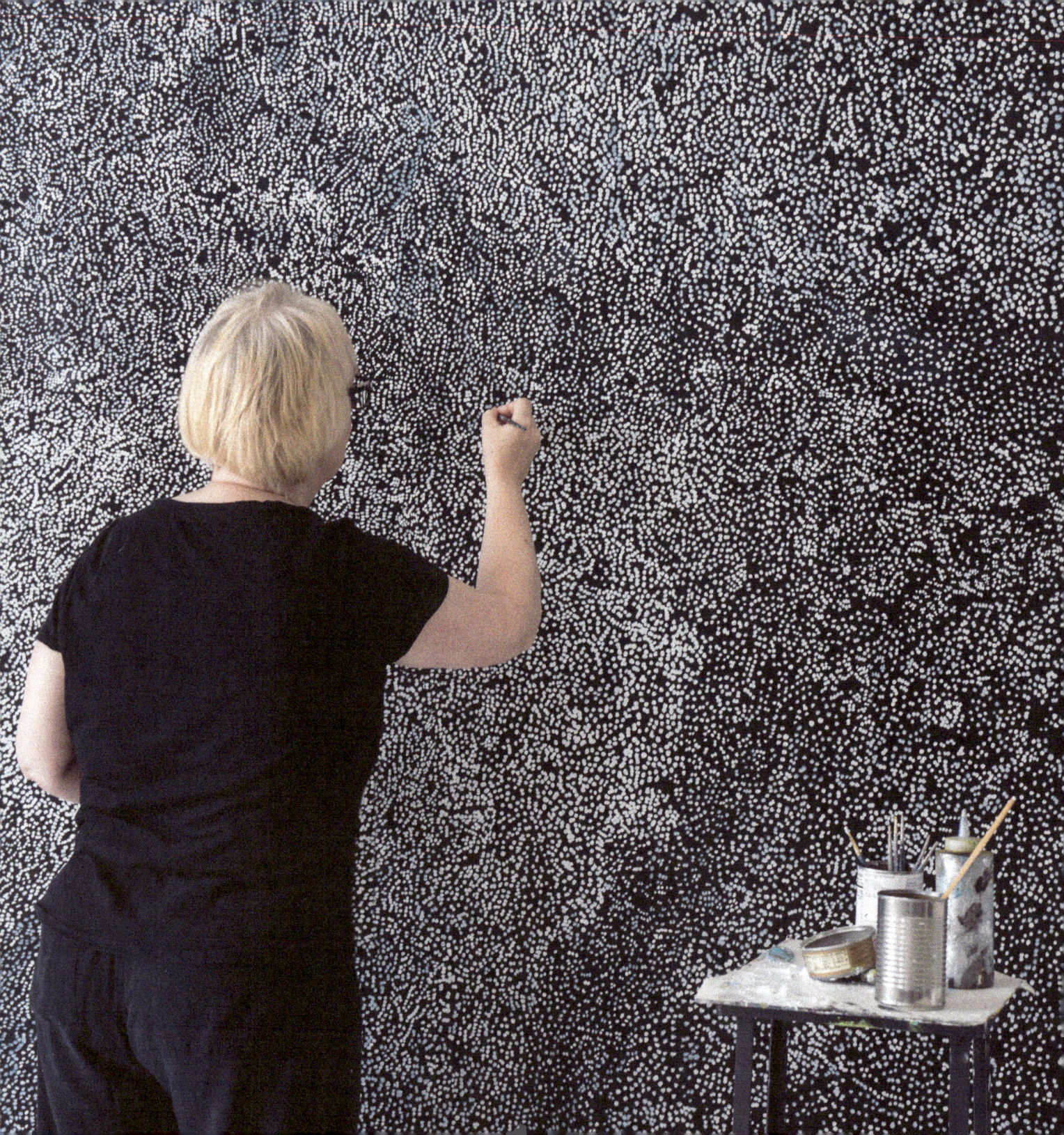

## A Year Inside

Almost every painting I made this year was either black or gray. I painted the frost on the studio window, sequined fabric, and several landscapes, all in that palette. In a year when our lives were reduced to a room, I painted the window - not what was beyond it, but what was on its surface - the invisible barrier and the cold. I painted some of these on large canvases and took weeks navigating my way across the frost like it was a vast, deeply frozen landscape. I had nowhere to go, no one to see. I could take my time.

*it is the only way to slow the virus.*

*of isolation and things are beginning to break down.*

*New death toll: 100,000 deaths today.*

*News about the coronavirus is worsening.*

*I have curtailed all social activities. I think*

*It's around day 54*

I want the painting to seem as though it is Nothing. Nothing going on here. But then you see all the vibrating energy underneath.

*Freezing Point*, 48" x 48", oil on canvas, 2021

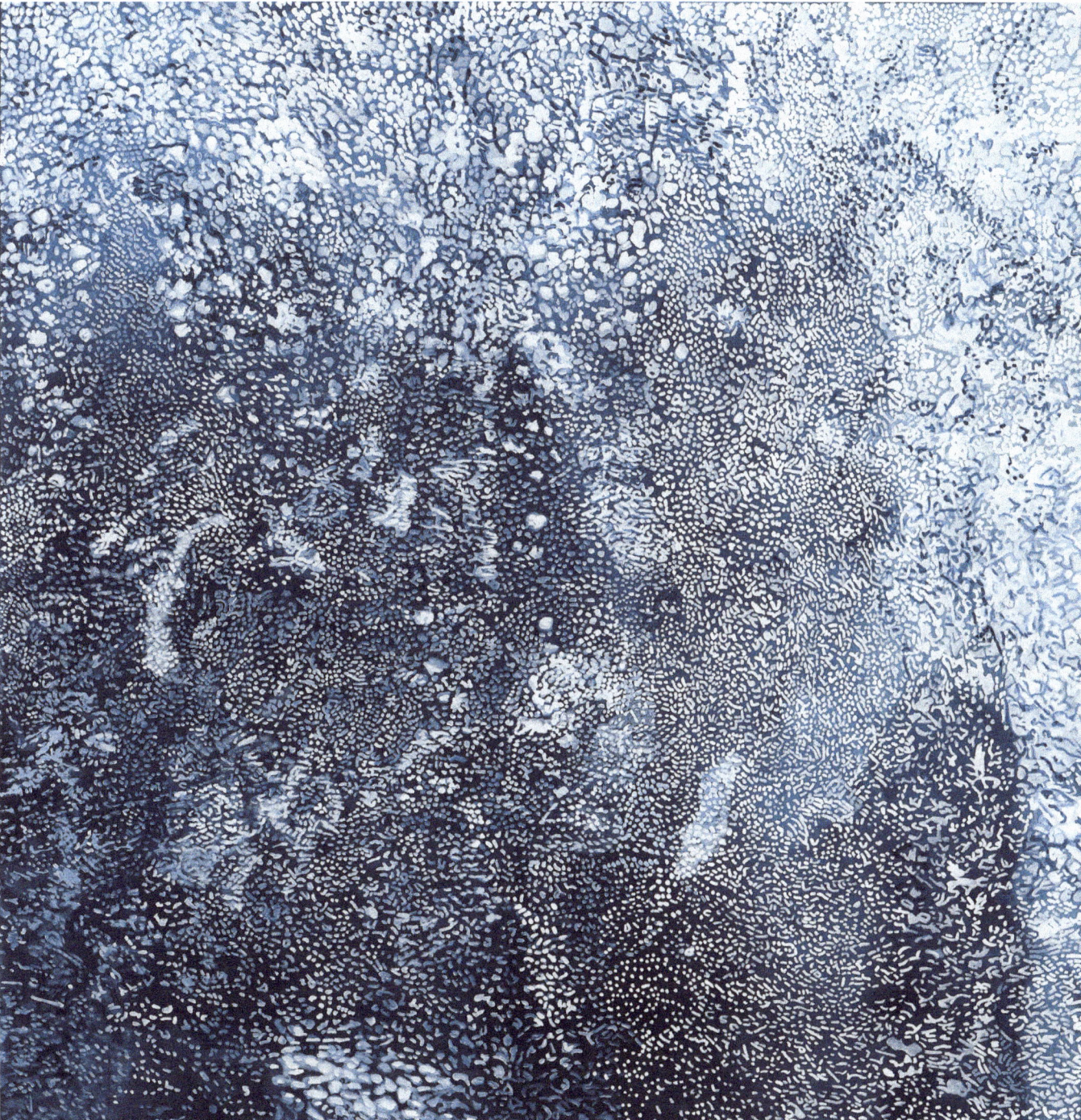

*Melting Frost,* 62" x 44", oil on canvas, 2020

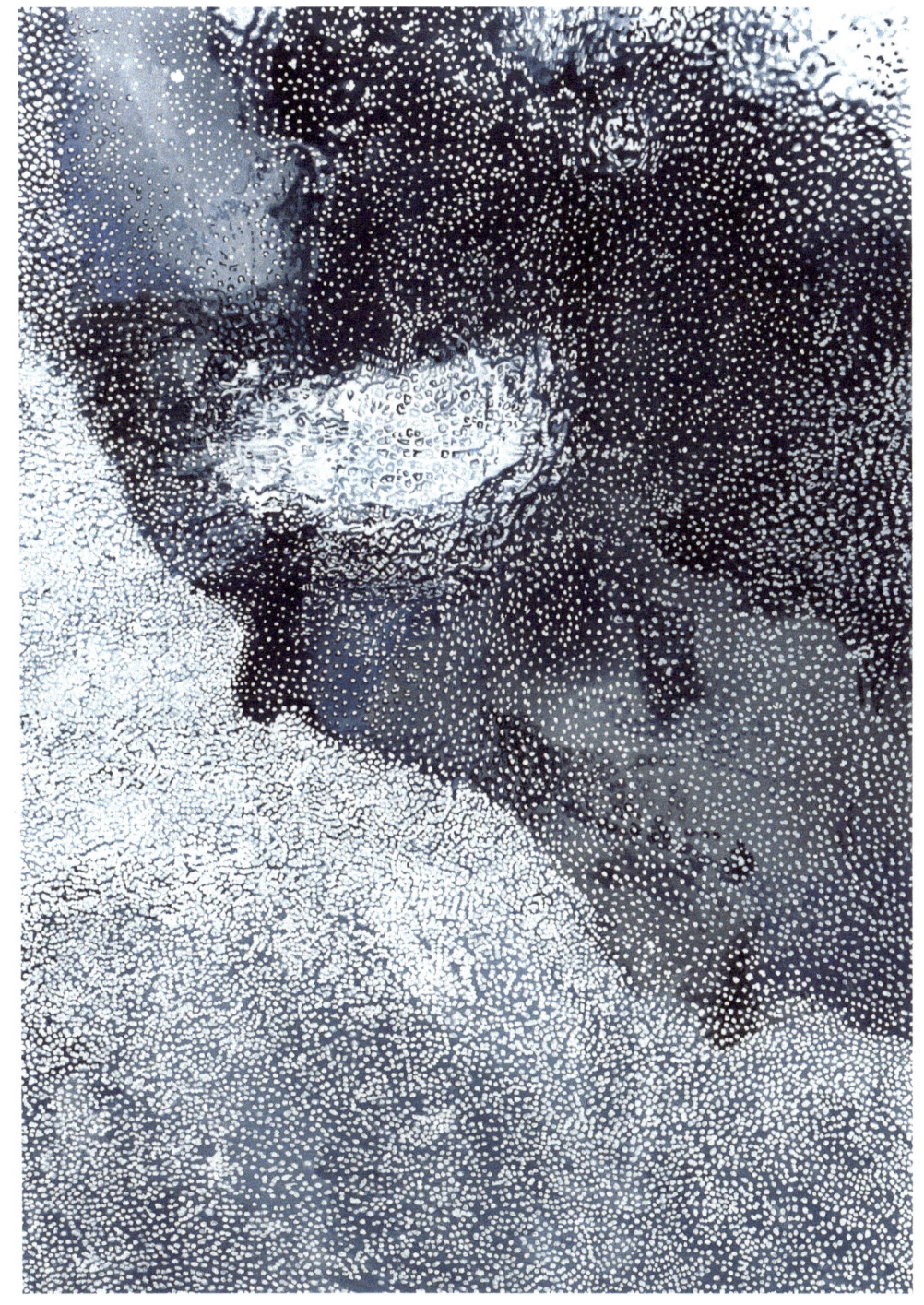

*Frost in Studio,* 60" x 36", oil on canvas, private collection, 2020

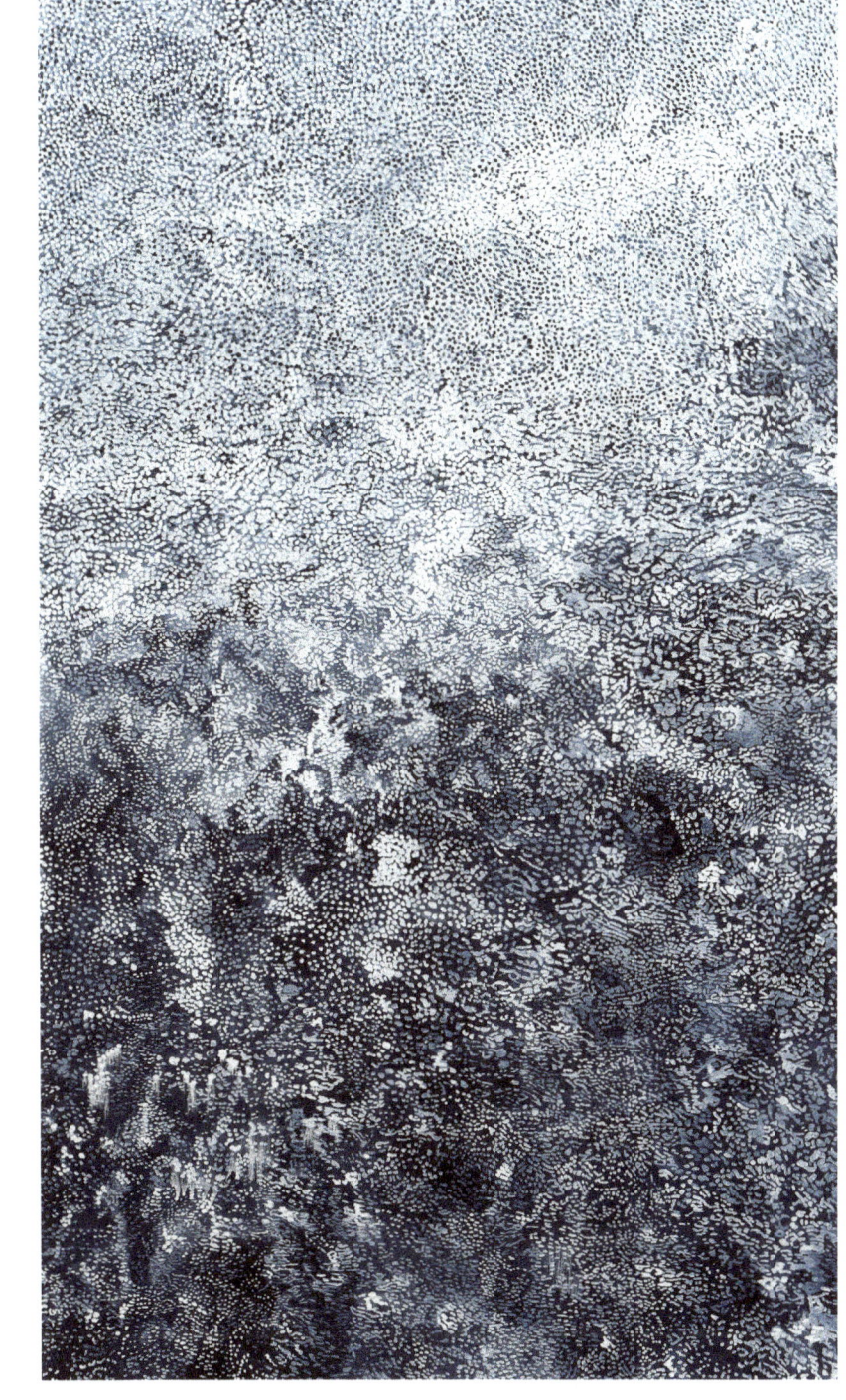

*Frost on Window,* 70" x 53", oil on canvas, private collection, 2020

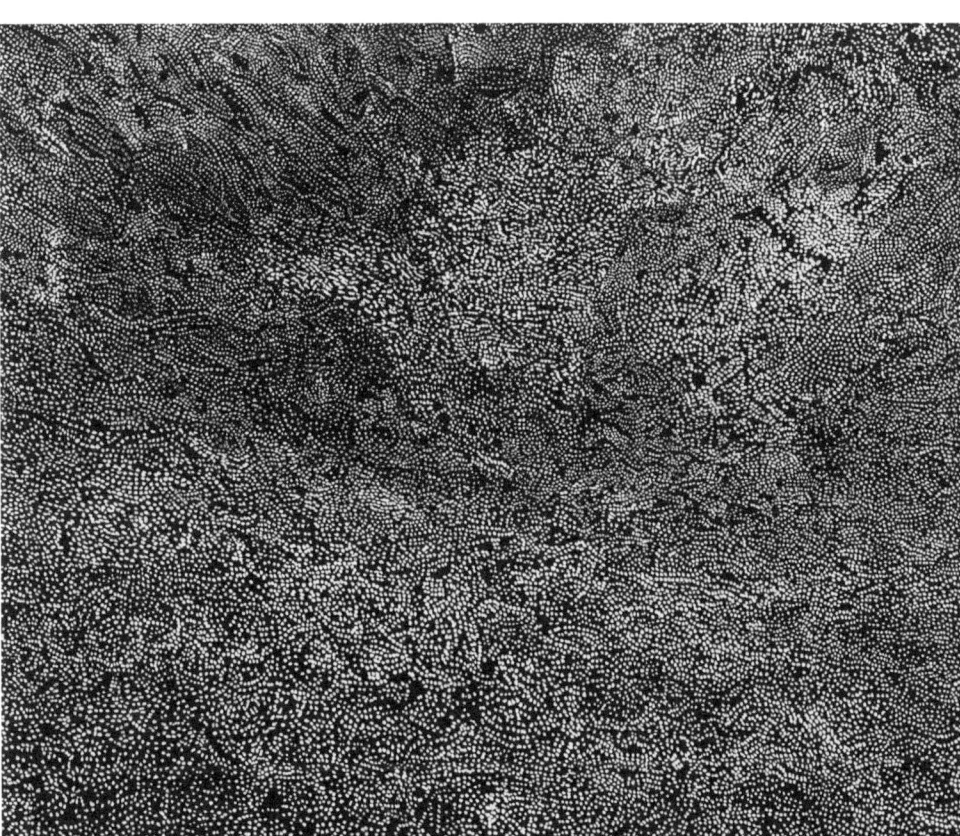

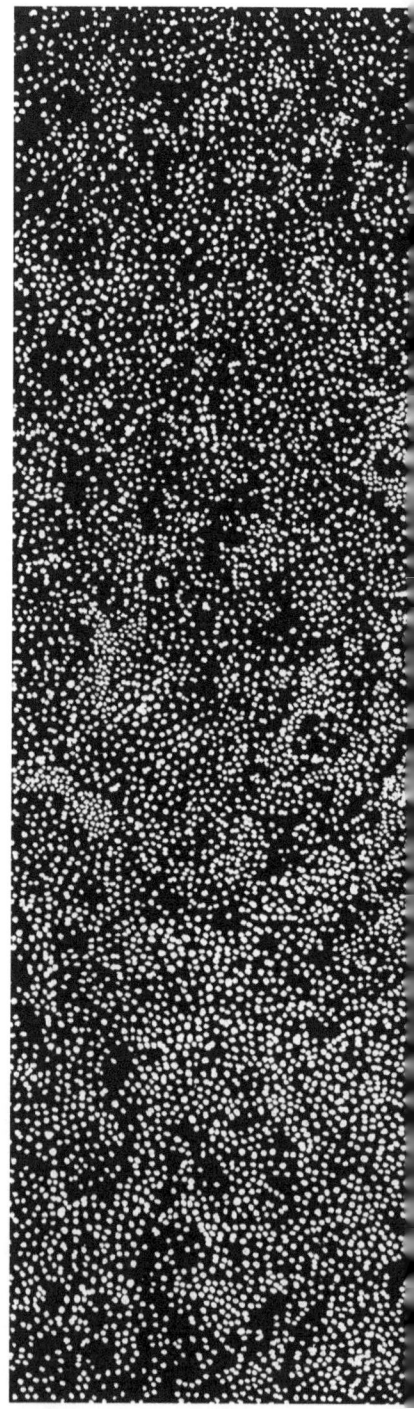

*Window Frost,* 65" x 94", oil on canvas, 2020

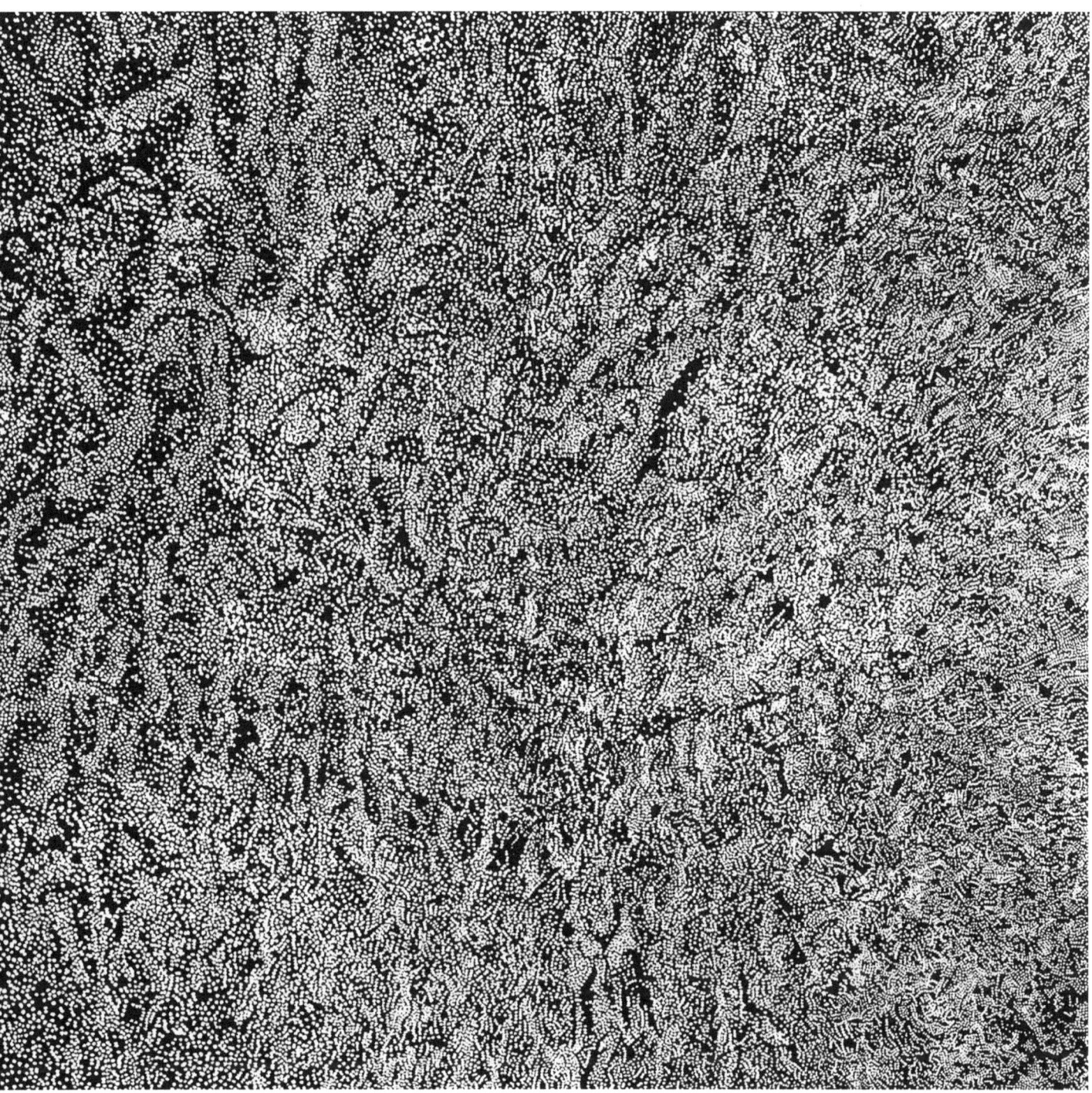

*The year has been filled with so much death.*

*been exhausting for all of us. Can't wait until this nightmare is*

*The only thing that matters is the work.*

*We still don't know who the President is.*

*The election has*

*COVID is raging out of control.*

I like the idea of breaking the picture plane, having something appear to be glittering and dimensional, but also abstract and unrecognizable.

*Sequins,* 48" x 36 ", oil on canvas, 2021

*The only thing that matters is the work.*

*We still don't know who the President is.*

*The election has*

*COVID is raging out of control.*

I like the idea of breaking the picture plane, having something appear to be glittering and dimensional, but also abstract and unrecognizable.

*Sequins,* 48" x 36", oil on canvas, 2021

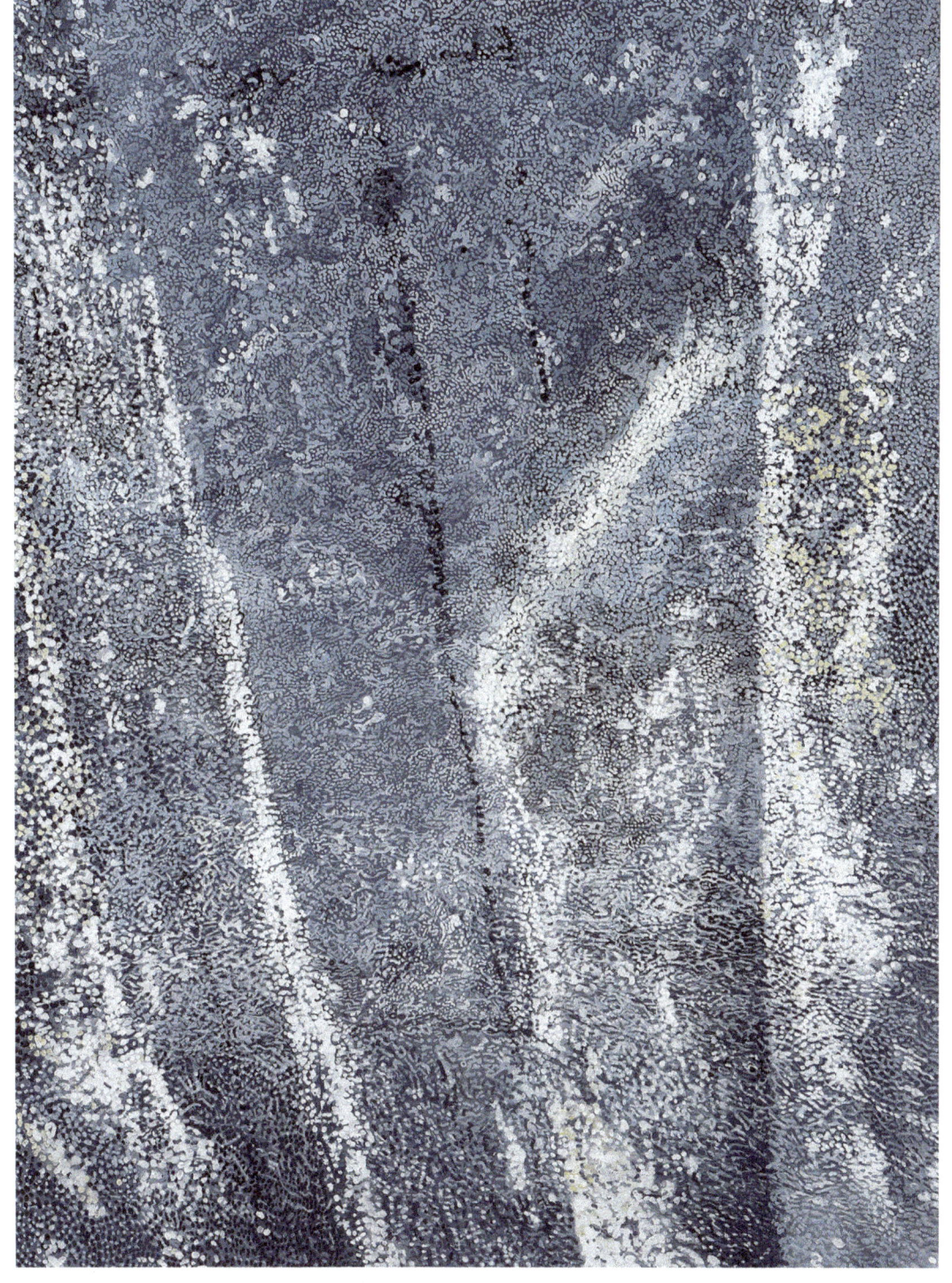

*around the country report being on the point of collapse.*

*News about the siege of the capitol d*

*The virus situation is becoming drastic. Many hospitals*

*End of the year and everybody is saying "Good riddance,"*

*nates the airwaves.*

Night after night as I peered into my Netflix world, I started to travel through the winter landscapes on my screen. In the background of numerous northern police procedurals, I moved like a tourist snapping the view out their window, or behind their victim frozen in the snow. My landscape was as two dimensional as my life.

*Silver Summit*, 48" x 48", oil on canvas, 2021

*Northward Lying,* 48" x 48", oil on canvas, 2021

*Forest in Fog,* 36.75" x 76.75", oil on canvas, 2021 (following page)

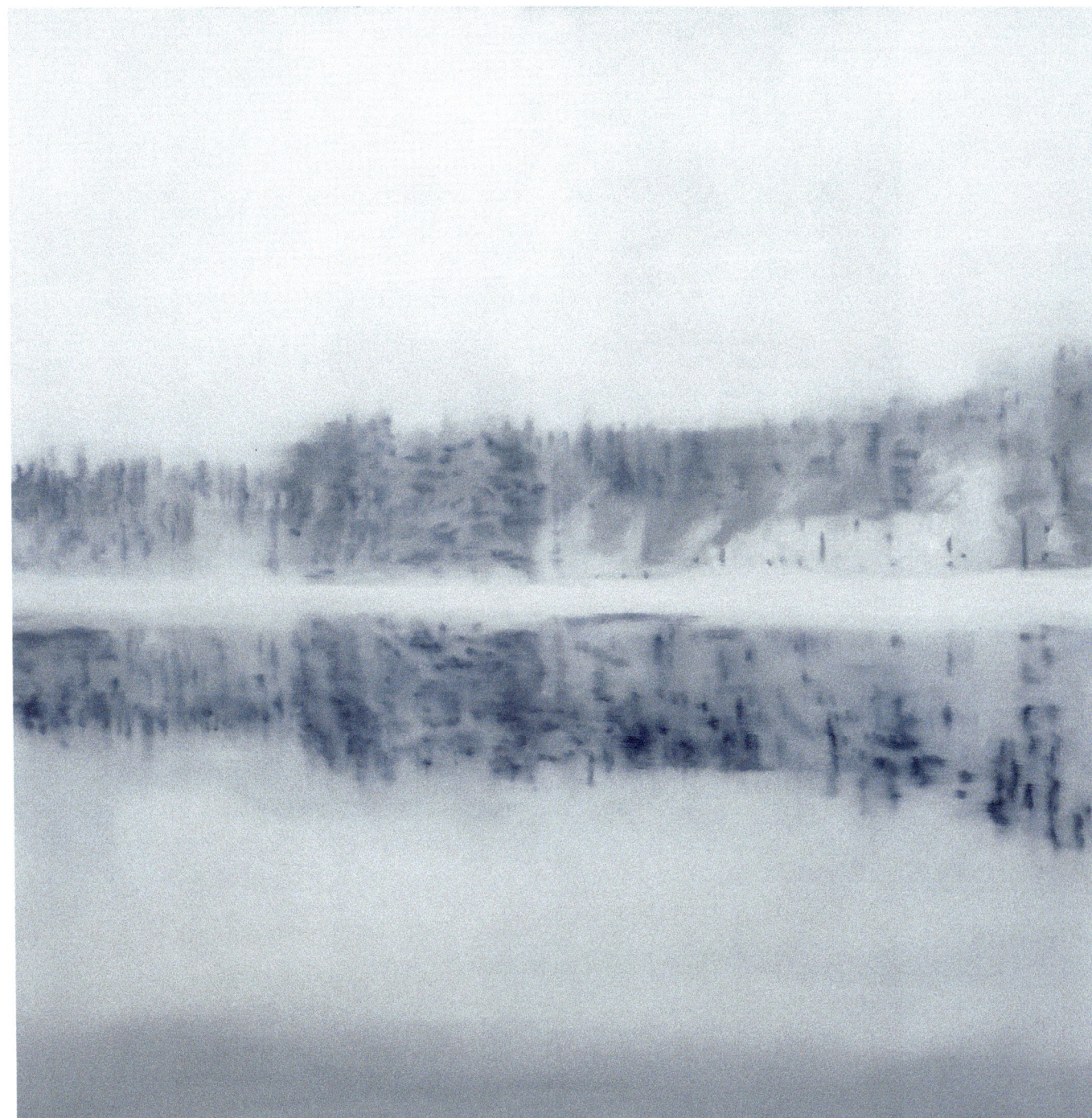

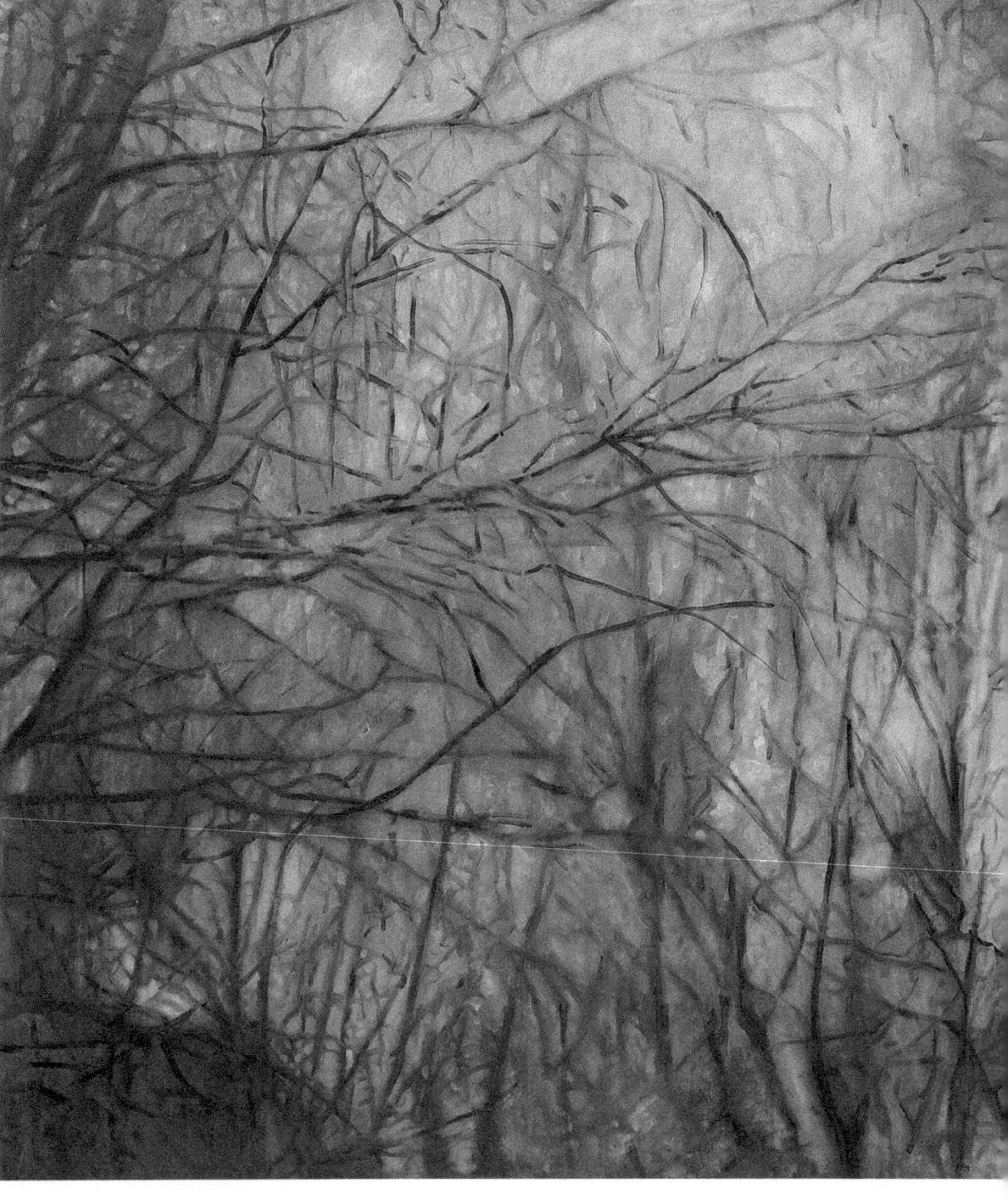

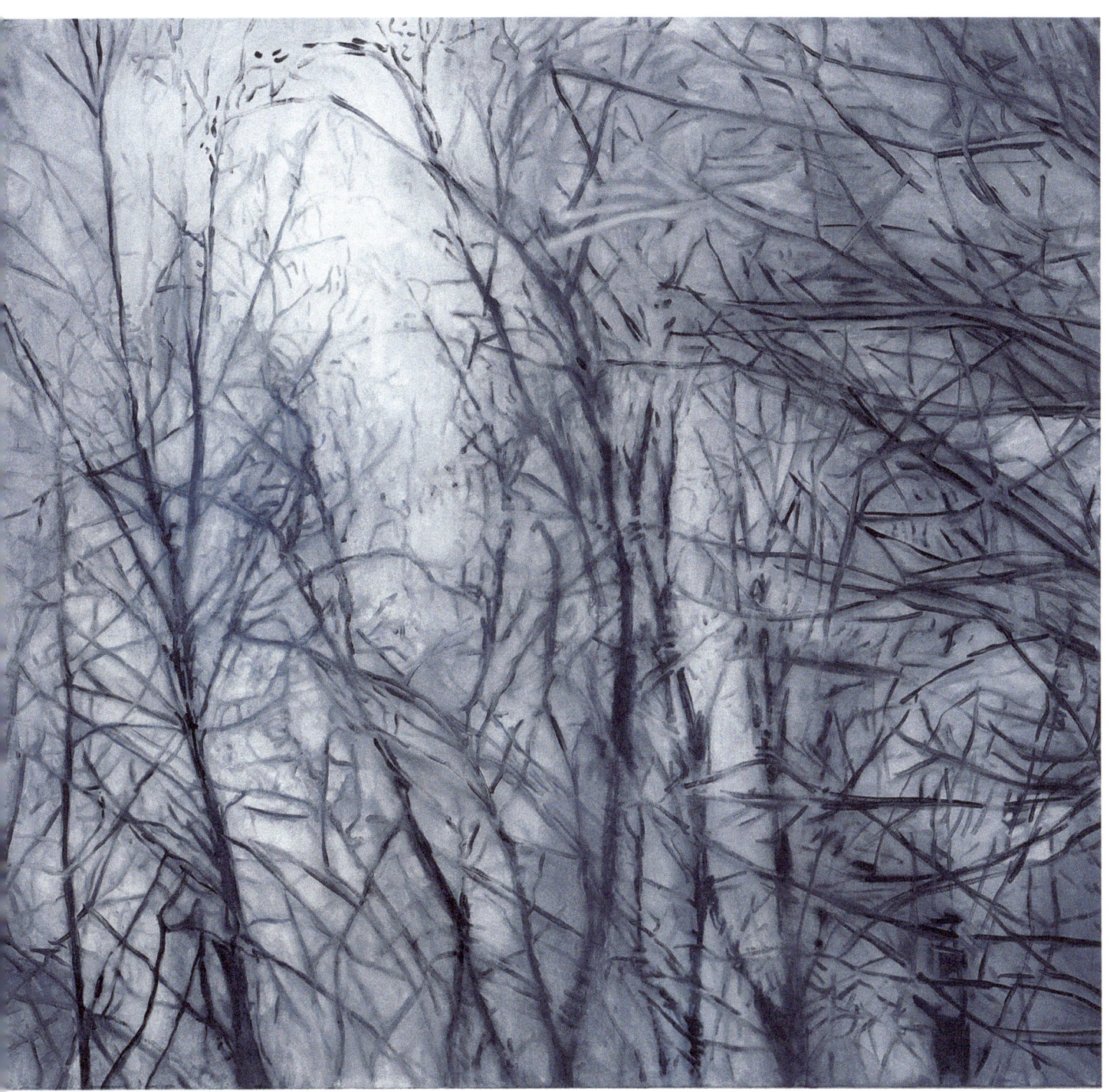

*since the election.*

*It felt amazing working today. The first day I felt like myself*

*Got my first vaccine today. I felt real joy getting it.*

*Tomorrow is my second vaccine.*

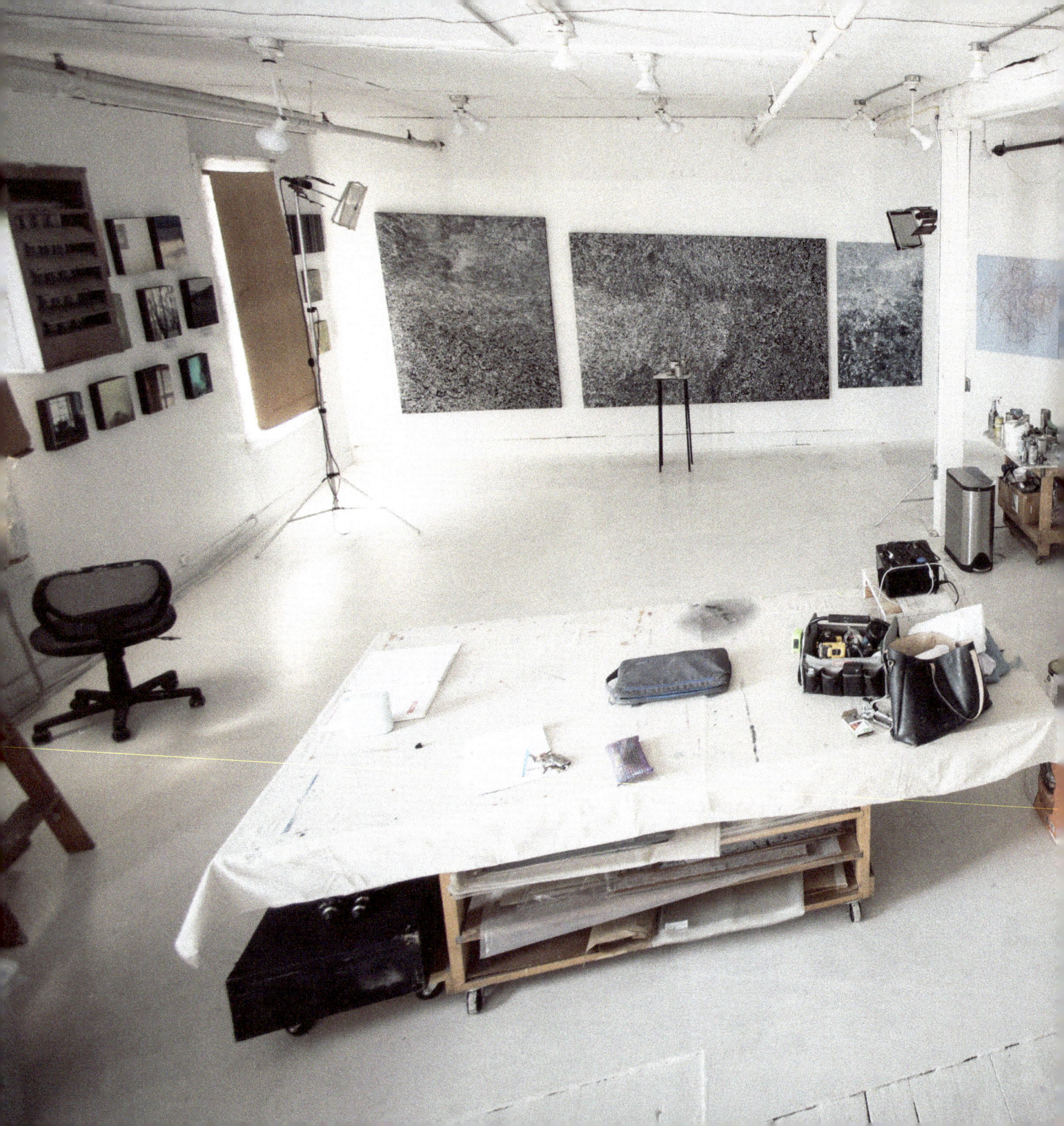

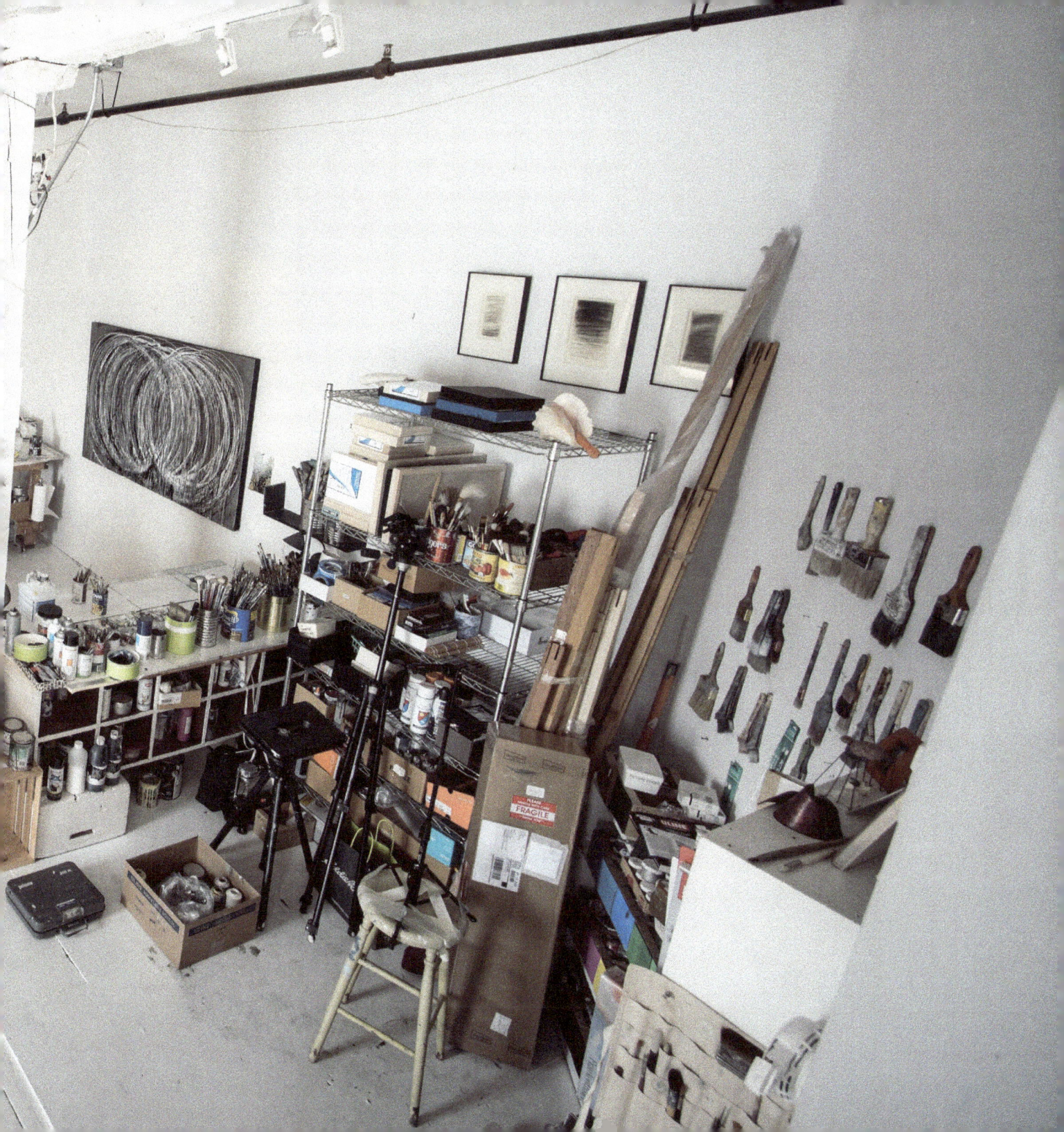

This Year Inside left me contemplating the edges of my world, the barrier, and the reach.

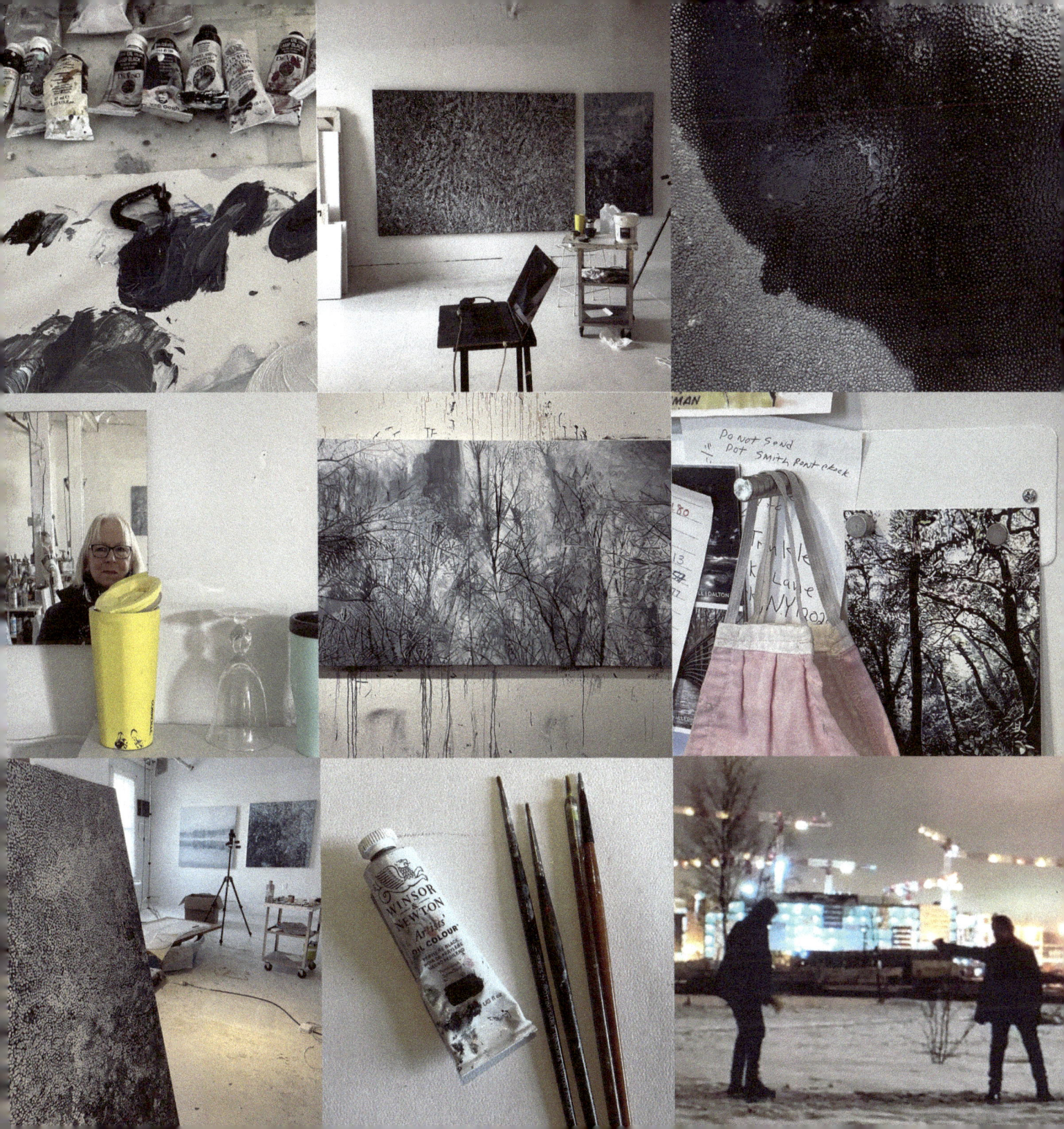

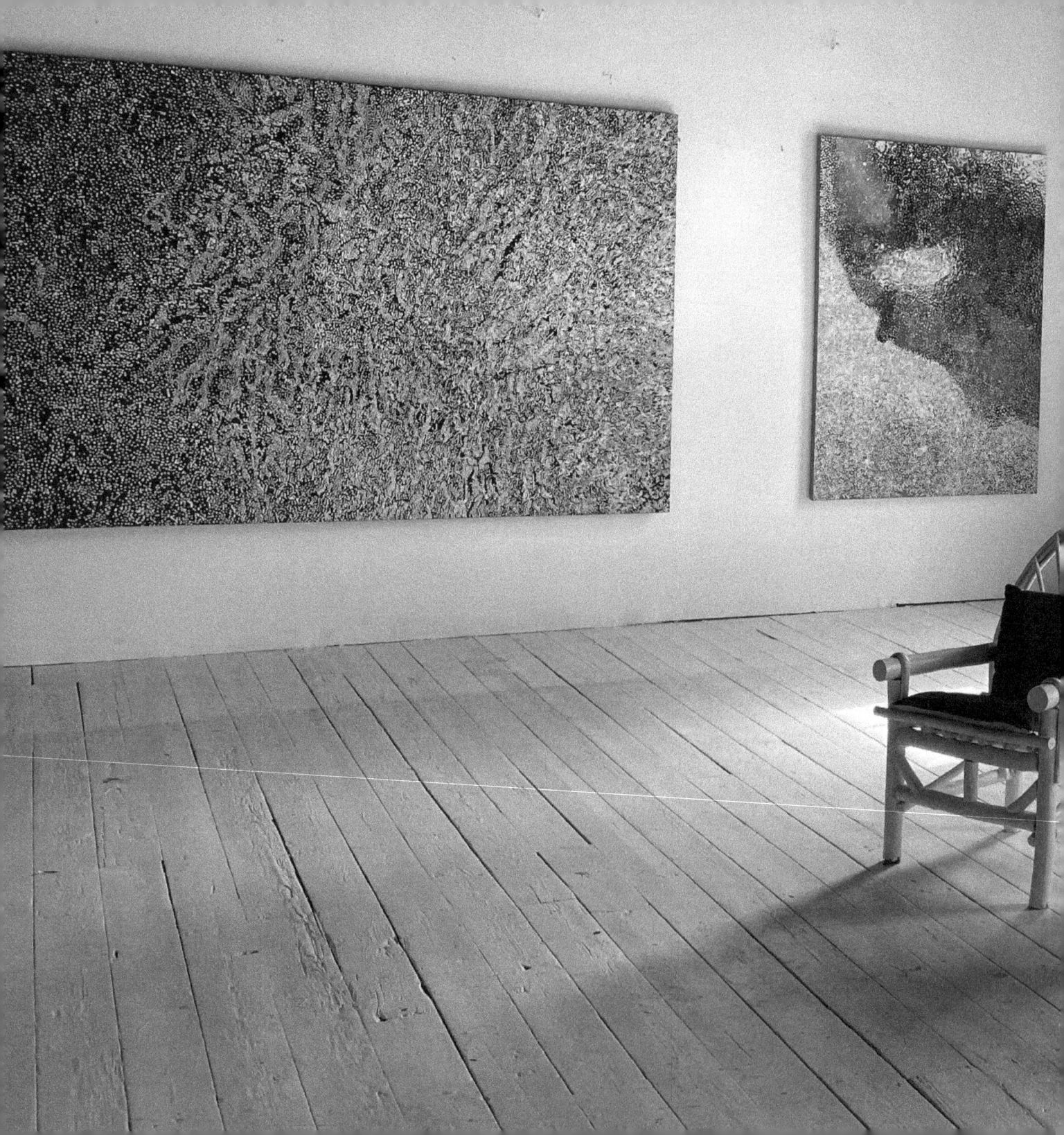

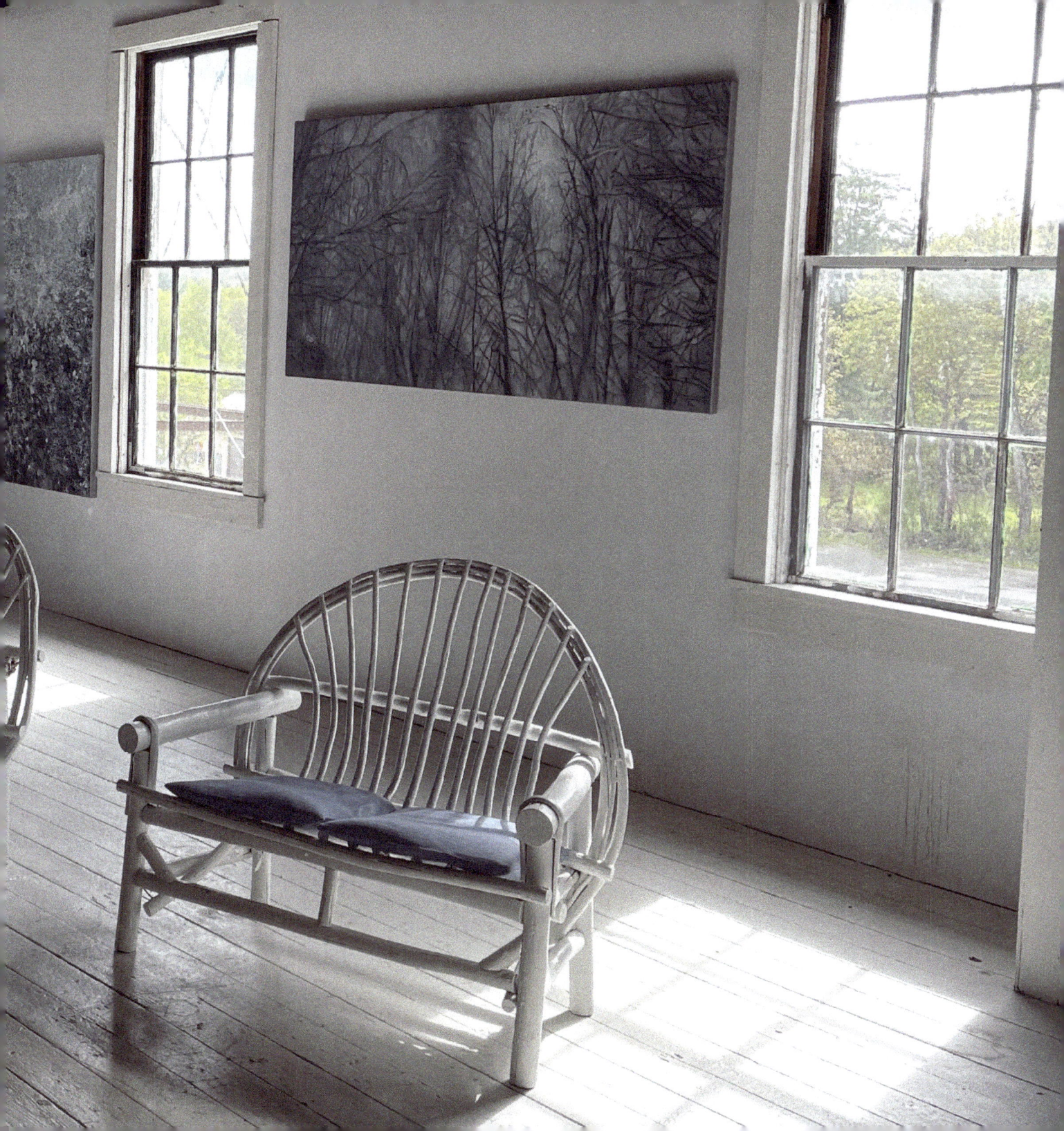

To see more about A Year Inside visit the viewing room on
www.leslieparke.com

www.ingramcontent.com/pod-product-compliance
Lightning Source LLC
Chambersburg PA
CBHW041921180526
45172CB00013B/1353